ANNE GEDDES ®

www.annegeddes.com

© 2003 Anne Geddes

The right of Anne Geddes to be identified as the Author
of the Work has been asserted by her in accordance with
the Copyright, Designs and Patents Act 1988.

First published in 2003 by Photogenique Publishers
(a division of Hodder Moa Beckett)
4 Whetu Place, Mairangi Bay, Auckland, New Zealand

This edition published in North America in 2003
by Andrews McMeel Publishing
4520 Main Street, Kansas City, MO 64111-7701

Produced by Kel Geddes
Printed in China by Midas Printing Ltd, Hong Kong

ISBN 0-7407-4003-2

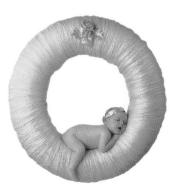

The Twelve Days
of Christmas

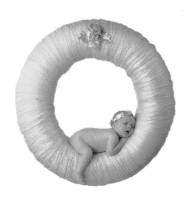

ANNE GEDDES

On the first day of Christmas
My true love gave to me

A partridge in a pear tree.

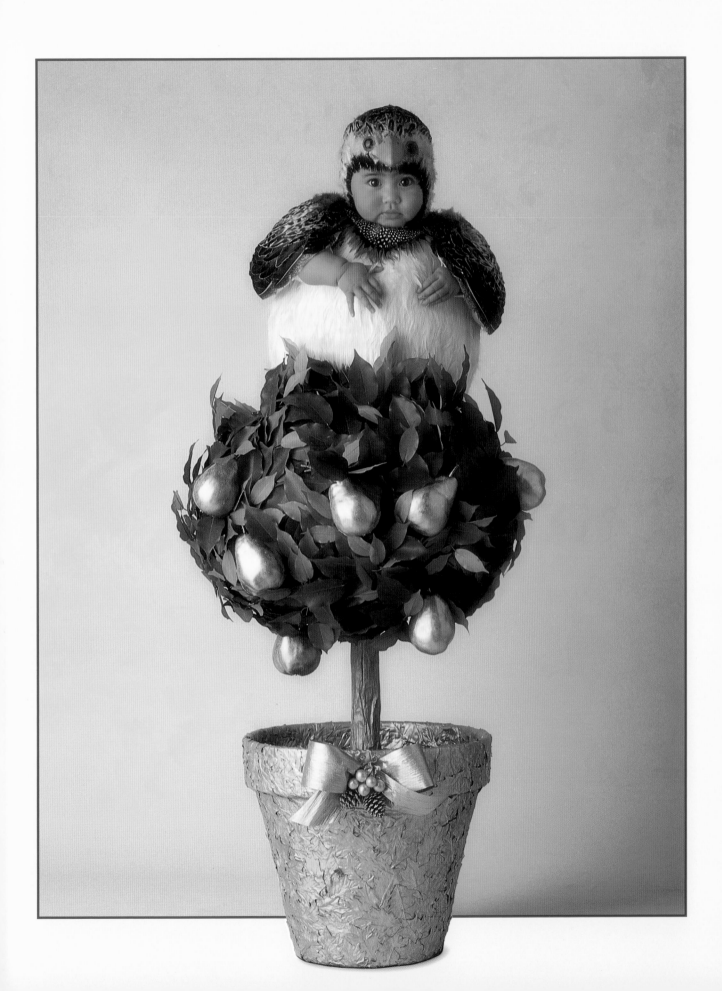

On the second day of Christmas
My true love gave to me

Two turtledoves
And a partridge in a pear tree.

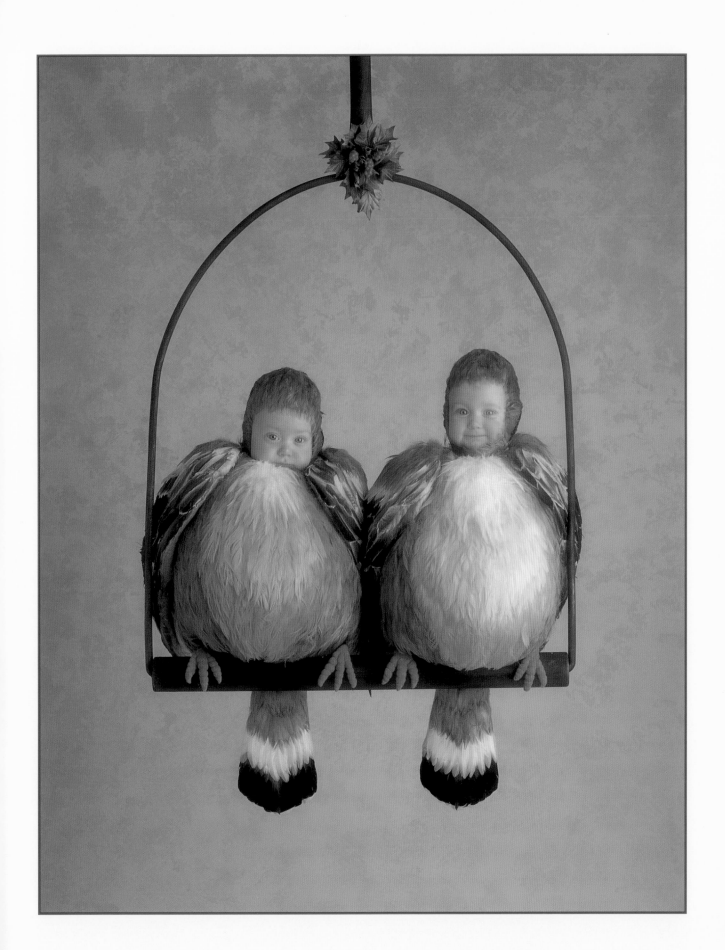

On the third day of Christmas
My true love gave to me

Three French hens
Two turtledoves
And a partridge in a pear tree.

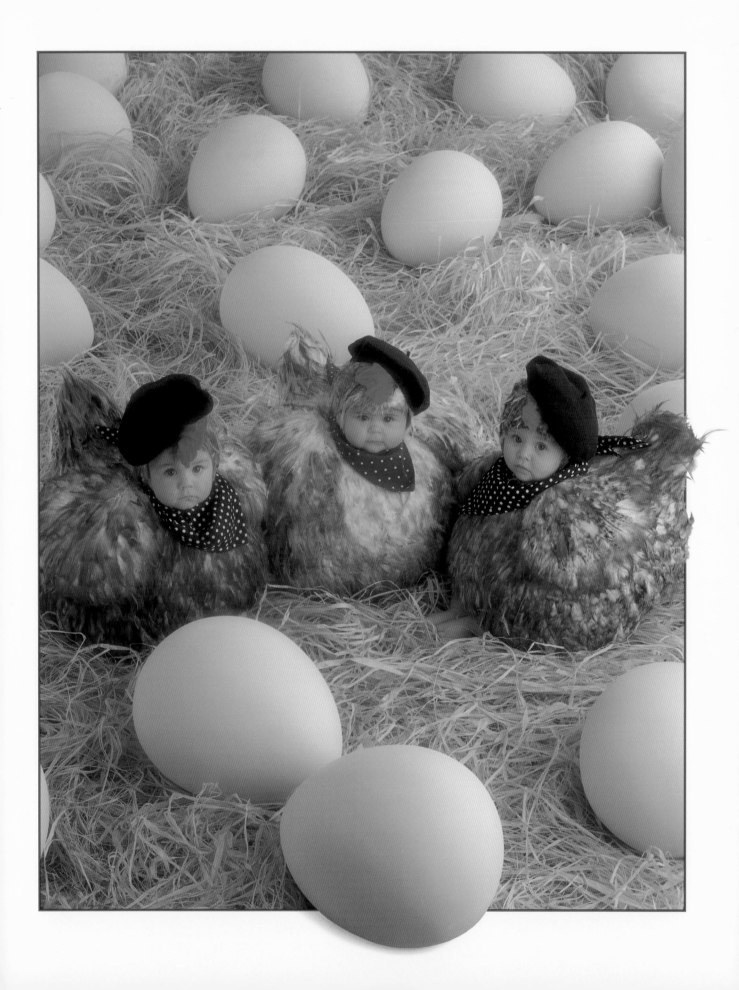

On the fourth day of Christmas
My true love gave to me

Four calling birds
Three French hens
Two turtledoves
And a partridge in a pear tree.

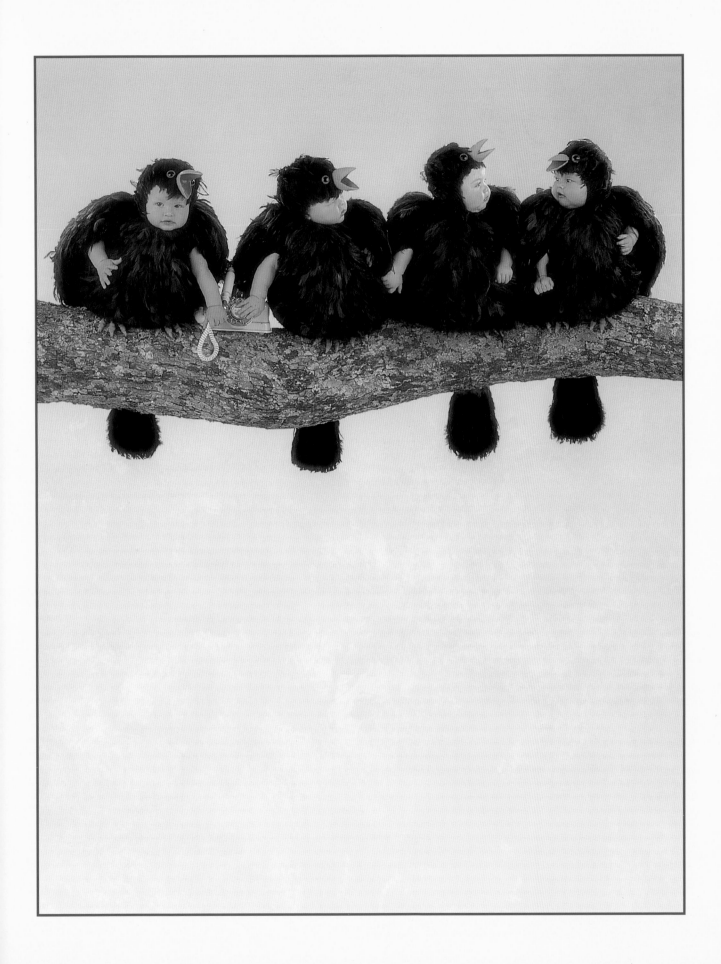

On the fifth day of Christmas
My true love gave to me

Five gold rings
Four calling birds
Three French hens
Two turtledoves
And a partridge in a pear tree.

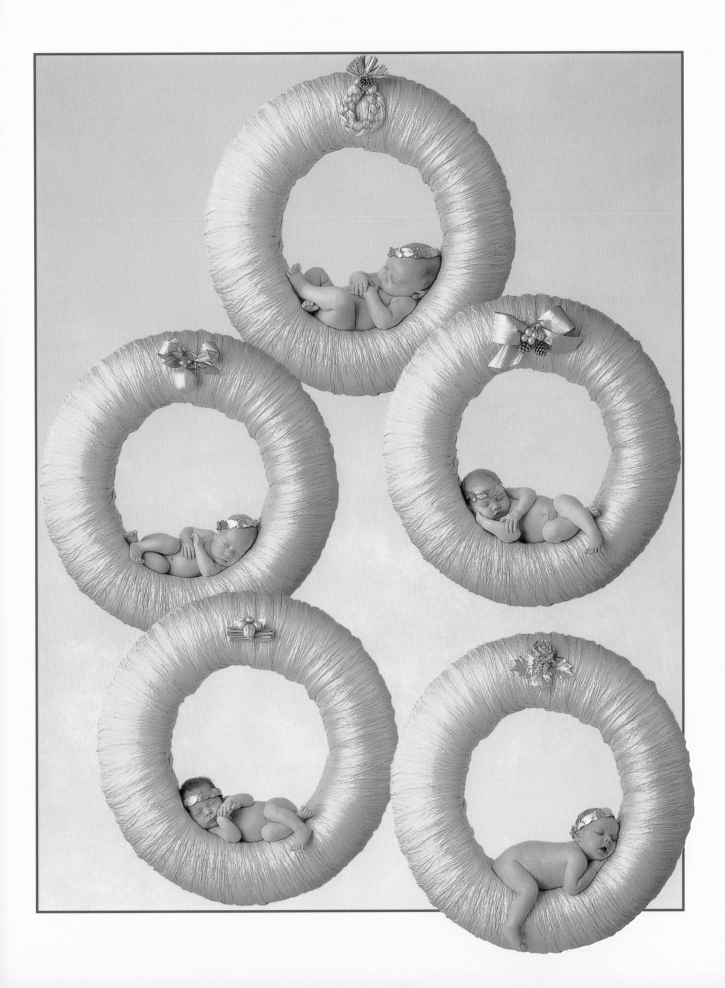

On the sixth day of Christmas
My true love gave to me

Six geese a-laying
Five gold rings
Four calling birds
Three French hens
Two turtledoves
And a partridge in a pear tree.

On the seventh day of Christmas
My true love gave to me

Seven swans a-swimming
Six geese a-laying
Five gold rings
Four calling birds
Three French hens
Two turtledoves
And a partridge in a pear tree.

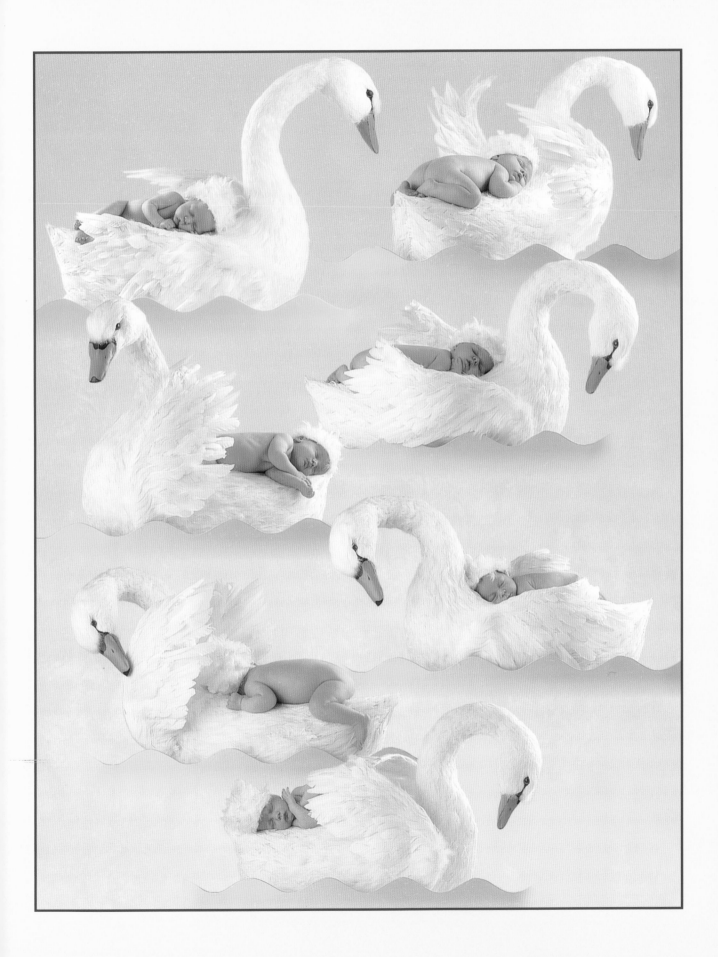

On the eighth day of Christmas
My true love gave to me

Eight maids a-milking
Seven swans a-swimming
Six geese a-laying
Five gold rings
Four calling birds
Three French hens
Two turtledoves
And a partridge in a pear tree.

On the ninth day of Christmas
My true love gave to me

Nine ladies dancing
Eight maids a-milking
Seven swans a-swimming
Six geese a-laying
Five gold rings
Four calling birds
Three French hens
Two turtledoves
And a partridge in a pear tree.

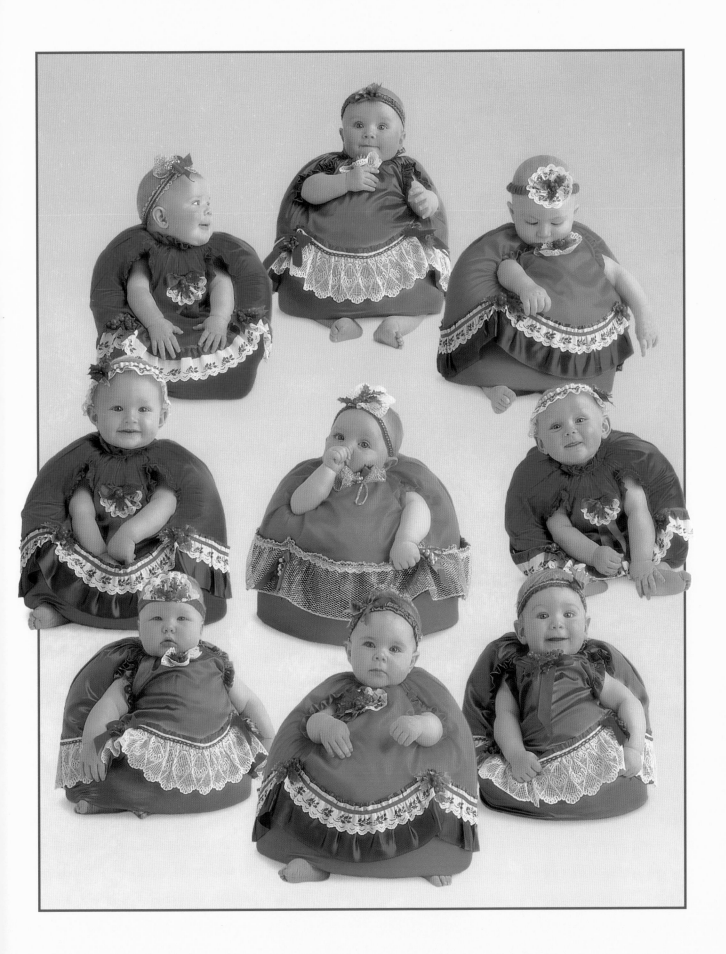

On the tenth day of Christmas
My true love gave to me

Ten lords a-leaping
Nine ladies dancing
Eight maids a-milking
Seven swans a-swimming
Six geese a-laying
Five gold rings
Four calling birds
Three French hens
Two turtledoves
And a partridge in a pear tree.

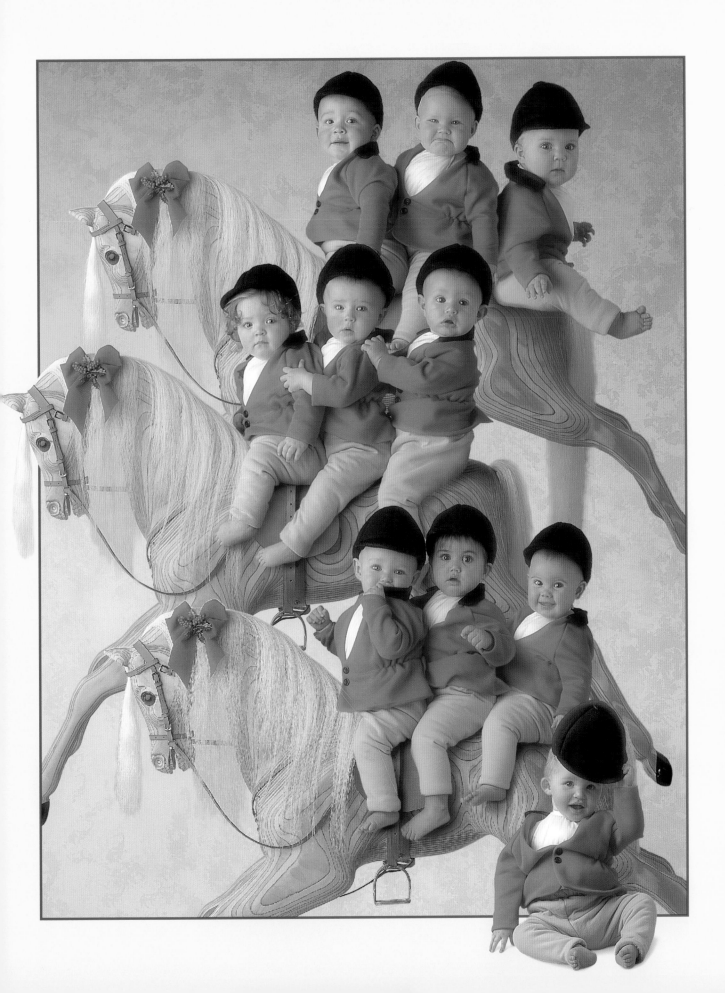

On the eleventh day of Christmas
My true love gave to me

Eleven pipers piping
Ten lords a-leaping
Nine ladies dancing
Eight maids a-milking
Seven swans a-swimming
Six geese a-laying
Five gold rings
Four calling birds
Three French hens
Two turtledoves
And a partridge in a pear tree.

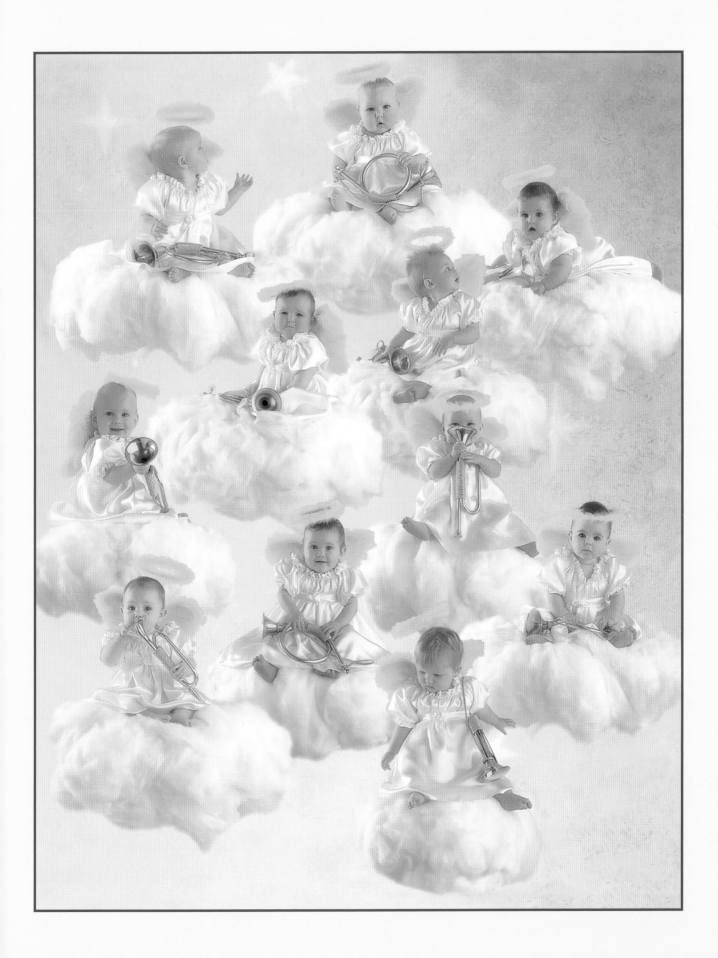

On the twelfth day of Christmas
My true love gave to me

Twelve drummers drumming
Eleven pipers piping
Ten lords a-leaping
Nine ladies dancing
Eight maids a-milking
Seven swans a-swimming
Six geese a-laying
Five gold rings
Four calling birds
Three French hens
Two turtledoves
And a partridge in a pear tree.

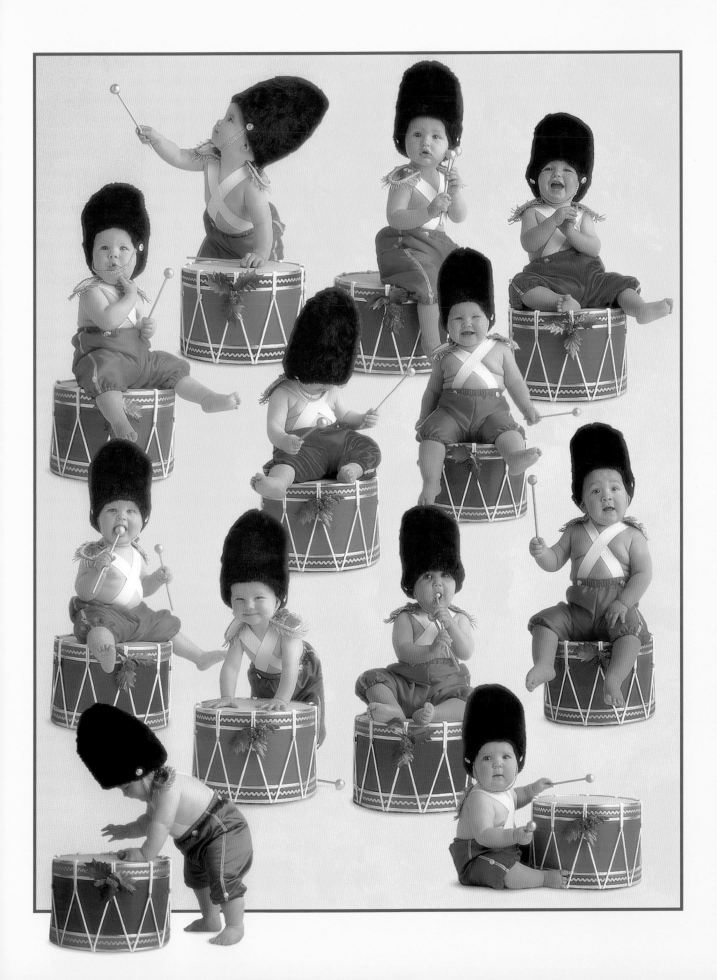

On the twelfth day of Christmas
My true love gave to me

Twelve drummers drumming

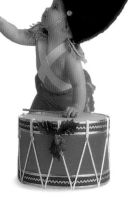

Eleven pipers piping

Ten lords a-leaping

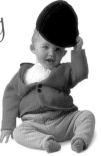

Nine ladies dancing

Eight maids a-milking

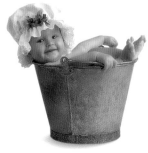

Seven swans a-swimming

Six geese a-laying

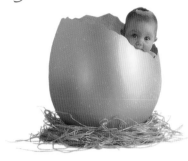

Five gold rings

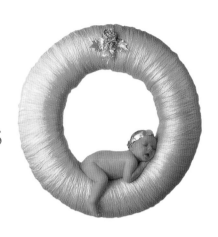

Four calling birds

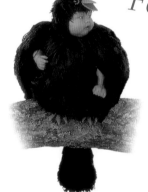

Three French hens

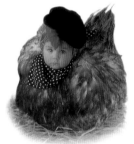

Two turtledoves

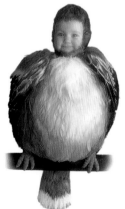

And a partridge in a pear tree.

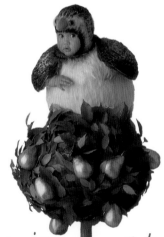

The Twelve Days of Christmas

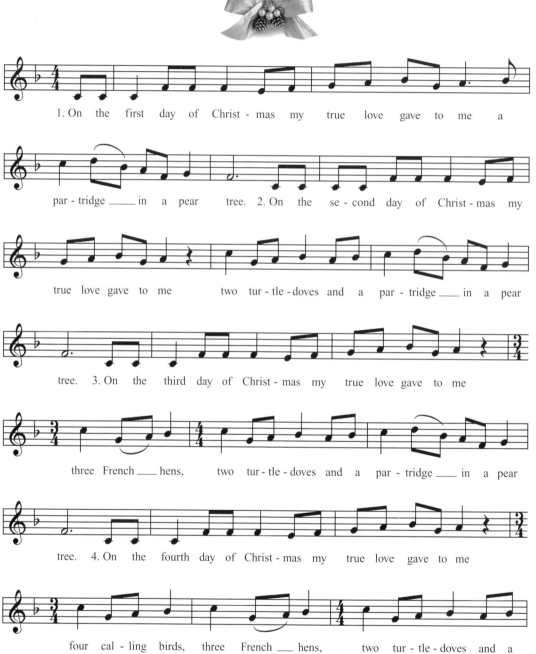

1. On the first day of Christ - mas my true love gave to me a

par - tridge ___ in a pear tree. 2. On the se - cond day of Christ - mas my

true love gave to me two tur - tle - doves and a par - tridge ___ in a pear

tree. 3. On the third day of Christ - mas my true love gave to me

three French ___ hens, two tur - tle - doves and a par - tridge ___ in a pear

tree. 4. On the fourth day of Christ - mas my true love gave to me

four cal - ling birds, three French ___ hens, two tur - tle - doves and a

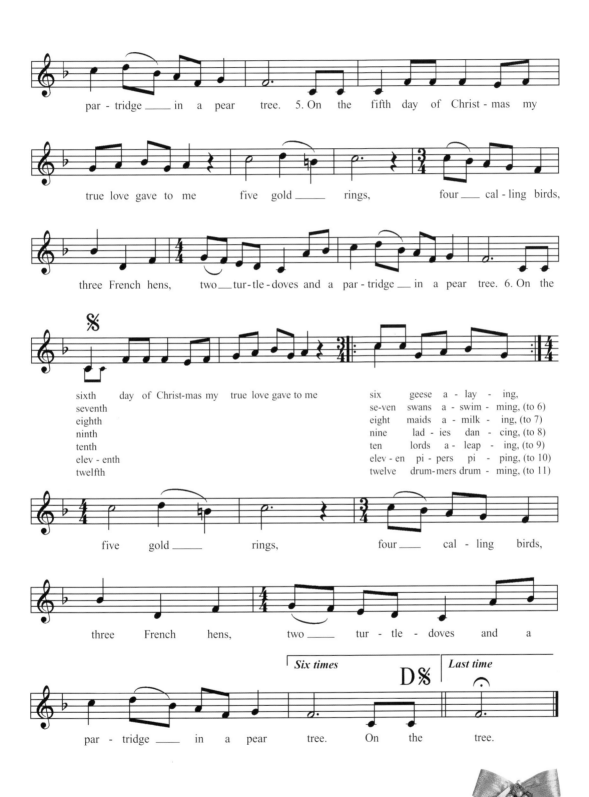